SOME MEMORIES OF DRAWINGS

GEORGIA O'KEEFFE

SOME
MEMORIES
OF
DRAWINGS

EDITED BY DORIS BRY

An Atlantis Editions Book

Published by
The University of New Mexico Press
Albuquerque

AN ATLANTIS EDITIONS BOOK PUBLISHED BY
THE UNIVERSITY OF NEW MEXICO PRESS

Library of Congress Cataloging-in-Publication Data

O'Keeffe, Georgia, 1887–1986.
Some memories of drawings.

"An Atlantis Editions book."
Bibliography: p. 103.
1. *O'Keeffe, Georgia, 1887–1986—Themes, motives—Catalogs.*
I. Bry, Doris. II. Title.
NC139.045A4 1988 741.973 88-10705
ISBN 0-8263-1113-X

I have picked flowers where I found them –
Have picked up sea shells and rocks and pieces of
wood where there were sea shells and rocks and
pieces of wood that I liked

When I found the beautiful white bones on the
desert I picked them up and took them home too

I have used these things to say what is to me the
wideness and wonder of the world as I live in it

—Georgia O' Keeffe, in the catalogue
of an exhibition of her 1943 paintings at An American Place

LIST OF PLATES

1 BLUE LINES. 1916. Watercolor. 25 × 19 inches
The Metropolitan Museum of Art, The Alfred Stieglitz Collection

2 DRAWING NO. 14. 1916. Charcoal. 24⅝ × 18½ inches

3 ABSTRACTION IX. 1916. Charcoal. 24⅝ × 18⅞ inches
The Metropolitan Museum of Art, The Alfred Stieglitz Collection

4 DRAWING NO. 8. 1916. Charcoal. 24¼ × 18¾ inches

5 DRAWING NO. 9. 1915. Charcoal. 25 × 19 inches

6 DRAWING NO. 15. 1916. Charcoal. 19 × 24½ inches

7 DRAWING NO. 13. 1915. Charcoal. 24¾ × 18⅞ inches
The Metropolitan Museum of Art, The Alfred Stieglitz Collection

8 DRAWING. 1917? Charcoal. 25 × 19 inches

9 DRAWING NO. 12. 1917. Charcoal. 24 × 19 inches

10 DRAWING NO. 17. 1919. Charcoal. 20 × 12¾ inches

11 EAGLE CLAW AND BEAN NECKLACE. 1934. Charcoal.
19 × 25⅛ inches
The Museum of Modern Art, New York,
given anonymously (by exchange)

12 DRAWING NO. 40. 1934. Pencil. 16⅛ × 11 inches

13 BANANA FLOWER. 1933. Charcoal. 21¾ × 14¾ inches
The Museum of Modern Art, New York,
given anonymously (by exchange)

Plates 1 through 9 were first exhibited by Alfred Stieglitz at his gallery *291* in 1916 and 1917.

SOME MEMORIES OF DRAWINGS

The first seven drawings are from a group that I made in 1915-16 when I first had the idea that what I had been taught was of little value to me except for the use of my materials as a language – charcoal, pencil, pen and ink, watercolor, pastel and oil. The use of my materials wasn't a problem for me. But what to say with them? I had been taught to work like others and after careful thinking I decided that I wasn't going to spend my life doing what had already been done.

I realized that I had things in my head not like what I had been taught – not like what I had seen – shapes and ideas so familiar to me that it hadn't occurred to me to put them down. I decided to stop painting, to put away everything I had done, and to start to say the things that were my own.

This was one of the best times in my life. There was no one around to look at what I was doing – no one interested – no one to say anything about it one way or another. I was alone and singularly free, working into my own, unknown – no one to satisfy but myself.

It was in the fall of 1915 that I decided not to use any color until I couldn't get along without it and I believe it was June before I needed blue.

Along the way I had probably looked very carefully at Chinese and Japanese paintings and calligraphy before I got to the BLUE LINES. I had practiced a good deal with the watercolor brush, but I considered that it would be impossible for me to have the fluency developed by the Orientals who always wrote with the brush.

BLUE LINES was first done with charcoal. Then there were probably five or six paintings of it with black watercolor before I got to this painting with blue watercolor that seemed right.

1 BLUE LINES. 1916. Watercolor. 25 × 19 inches

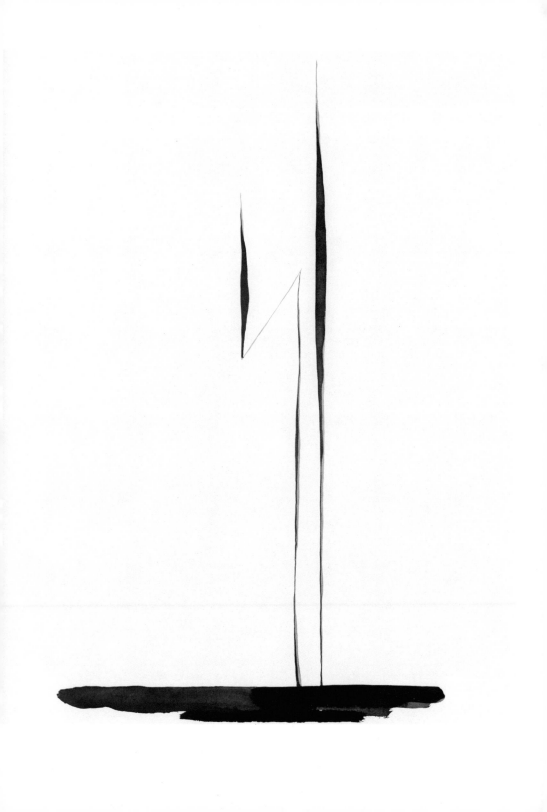

Walking down the hall of Columbia University Art Department, I heard music. Being curious, I opened the door and went in. The instructor was playing a low-toned record, asking the class to make a charcoal drawing from it. So I sat down and made a drawing too. Then he played a very different kind of record – a sort of high soprano sounding piece for another quick drawing. The two pieces were so different that you had to make two quite different drawings.

DRAWING NO. 14 is the one that I made at the time and it gave me an idea that I was very interested to follow – the idea of lines like sounds.

DRAWING NO. 14. 1916. Charcoal. 24⅝ × 18½ inches

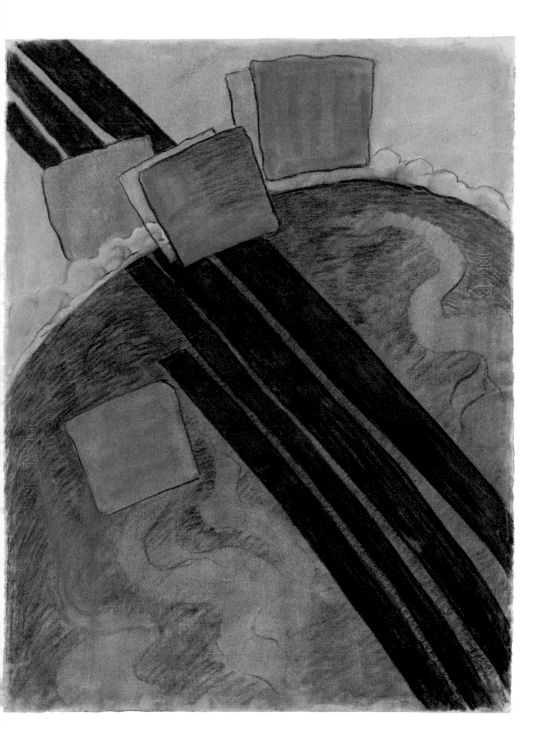

ABSTRACTION IX was first made with charcoal, then it was painted many times with red, and I finally went back to the charcoal. I even now have another way in my head that I might have done it.

I had been walking for a couple of weeks with a girl in the big woods somewhere in the North Carolina mountains. One morning before daylight, as I was combing my hair, I turned and saw her lying there – one arm thrown back, hair a dark mass against the white, the face half turned, the red mouth. It all looked warm with sleep.

3 ABSTRACTION IX. 1916. Charcoal. 24⅝ × 18⅞ inches

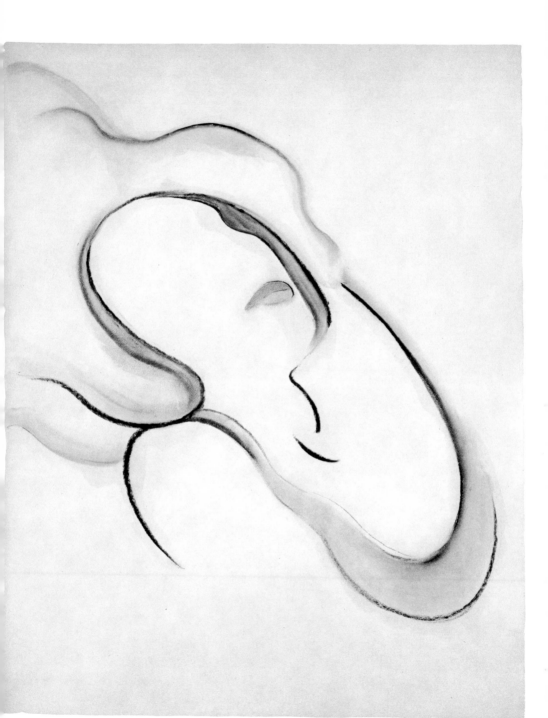

I have made this drawing several times – never remembering that I had made it before – and not knowing where the idea came from.

4 DRAWING NO. 8. 1916. Charcoal. 24¼ × 18¾ inches

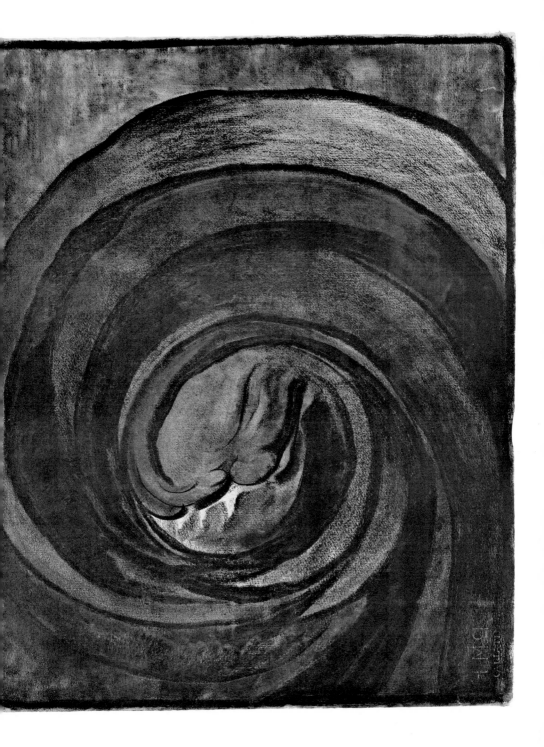

DRAWING NO. 9 is the drawing of a headache. It was a very bad headache at the time that I was busy drawing every night, sitting on the floor in front of the closet door.

Well, I had the headache, why not do something with it? So – here it is.

5 DRAWING NO. 9. 1915. Charcoal. 25 × 19 inches

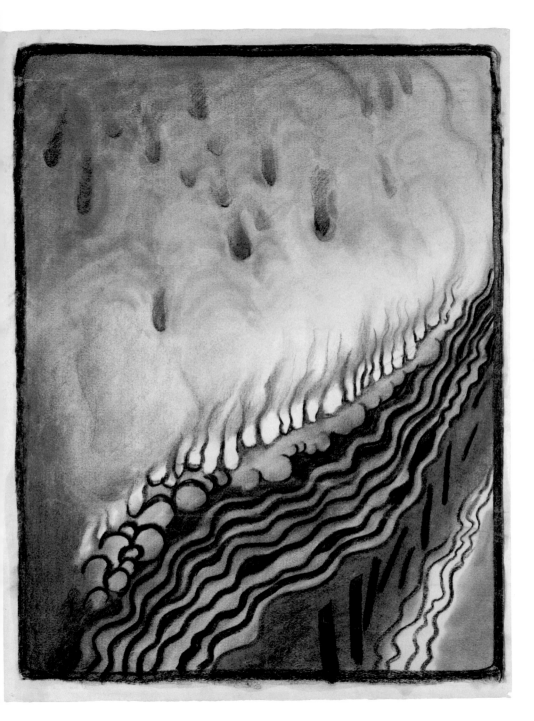

When I lived in Canyon, Texas, my sister Claudia
was with me. Saturdays, right after breakfast, we
often drove the twenty miles to the Palo Duro Can-
yon. It was colorful – like a small Grand Canyon,
but most of it only a mile wide. It was a place where
few people went unless they had cattle they hoped
had found shelter there in bad weather. The
weather seemed to go over it. It was quiet down in
the canyon. We saw the wind and snow blow
across the slit in the plains as if the slit didn't exist.

The only paths were narrow, winding cow paths.
There were sharp, high edges between long, soft
earth banks so steep that you couldn't see the bot-
tom. They made the canyon seem very deep. We
usually took different paths to the edge so that we
could climb down in new places. We sometimes
had to go down together holding to a horizontal
stick to keep one another from falling. It was usually
very dry, and it was a lone place. We never met
anyone there. Often as we were leaving we would
see a long line of cattle like black lace against the
sunset sky.

Those perilous climbs were frightening but they were wonderful to me and not like anything I had known before. The fright of the day was still with me in the night and I would often dream that the foot of my bed rose straight up into the air – then just as it was about to fall I would wake up.

This drawing came months afterward from days like that. Sometimes these drawings were made long after the situations they come from.

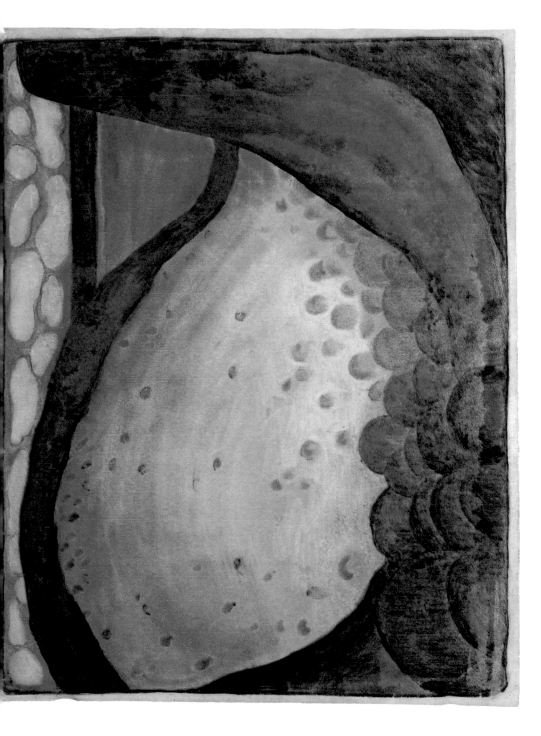

DRAWING NO. 13 came from many days in Palo Duro Canyon, simplified from the canyon landscapes.

7 DRAWING NO. 13. 1915. Charcoal. 24¾ × 18⅞ inches

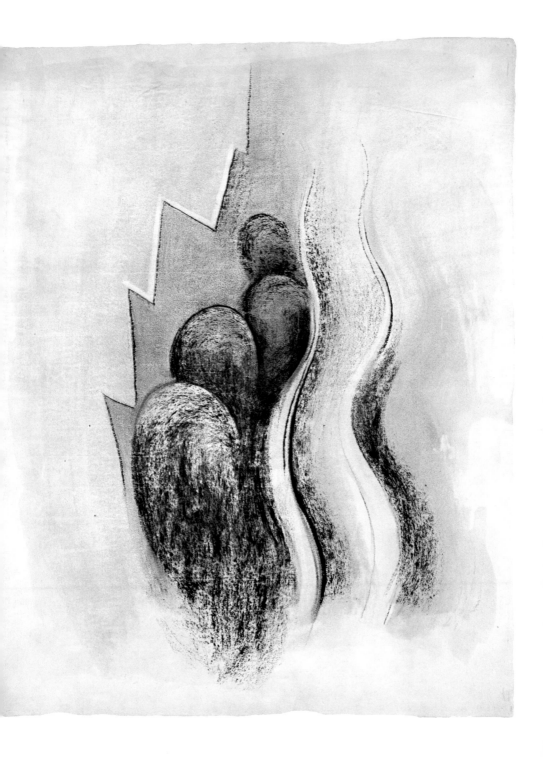

This is a drawing of something I never saw except in the drawing. When one begins to wander around in one's own thoughts and half-thoughts what one sees is often surprising.

8 DRAWING. 1917? Charcoal. 25 × 19 inches

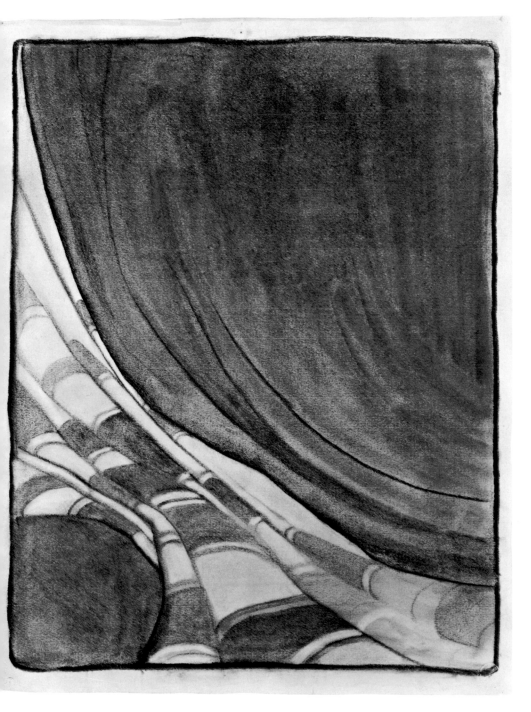

Maybe a kiss . . .

9 DRAWING NO. 12. 1917. Charcoal. 24 × 19 inches

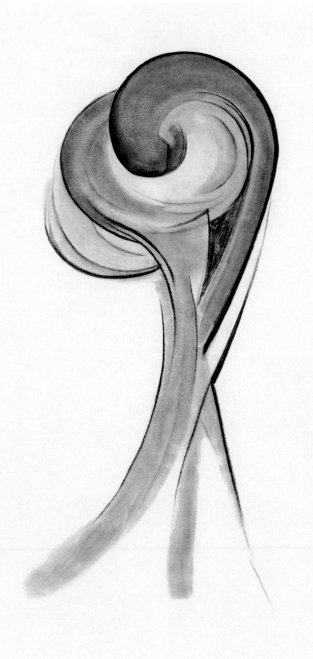

No comments, please.

10 DRAWING NO. 17. 1919. Charcoal. 20 × 12¾ inches

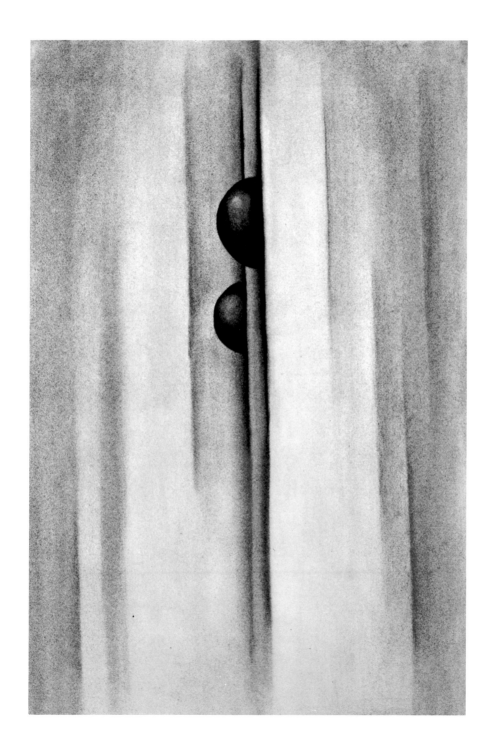

The spring I drove to New Mexico I went through a part of Colorado where there must have been many buffalo. One place, where I stayed a day or two, had many buffalo bones. Most of them had been dug out of the ground when parts protruded. I got this black necklace there. For the front the eagle claws were graduated in size from a very large one to very small ones where the beans began for the back of the necklace. It is very different from any necklace that one would find in New Mexico.

11 EAGLE CLAW AND BEAN NECKLACE. 1934. Charcoal. 19 × 25⅛ inches

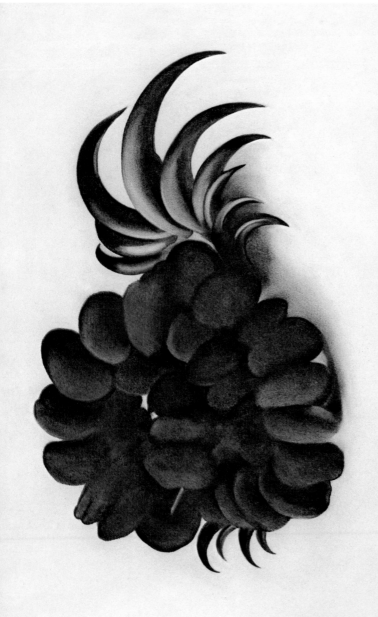

This is from the sea – a shell – and paintings
followed. Maybe not as good as this drawing.

12 DRAWING NO. 40. 1934. Pencil. 16⅛ × 11 inches

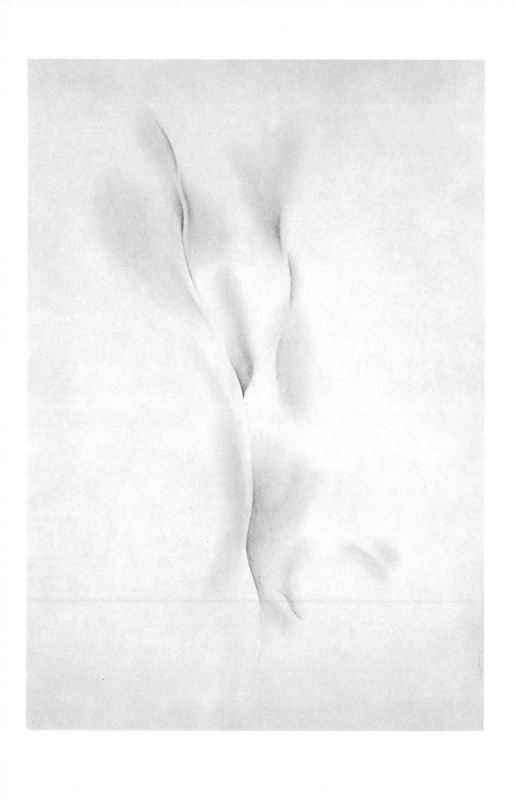

I spent a couple of months or more at Marie's house in Bermuda. Off to one side of the house was a large grove of banana trees in flower. The flowers were dark purplish red, large and heavy – and hung down. Each petal had a row of little white flowers under it. As the petal turns back and dies the little white flowers become bananas.

I made several drawings of banana flowers. It was too hot to work long outside and I never took a flower into the house. I didn't like to cut it.

13 BANANA FLOWER. 1933. Charcoal. 21¾ × 14¾ inches

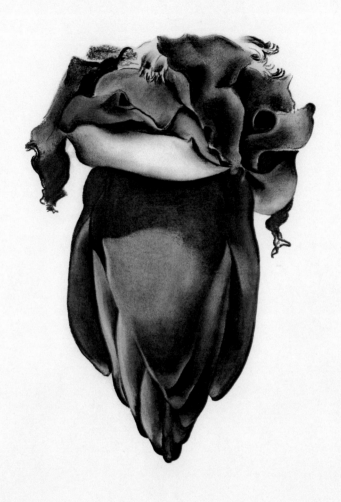

This is what I saw out a window where I lived for a short time.

14 THE CITY (NEW YORK ROOFTOPS). 1930's. Charcoal. 24⁹⁄₁₆ × 18¹³⁄₁₆ inches

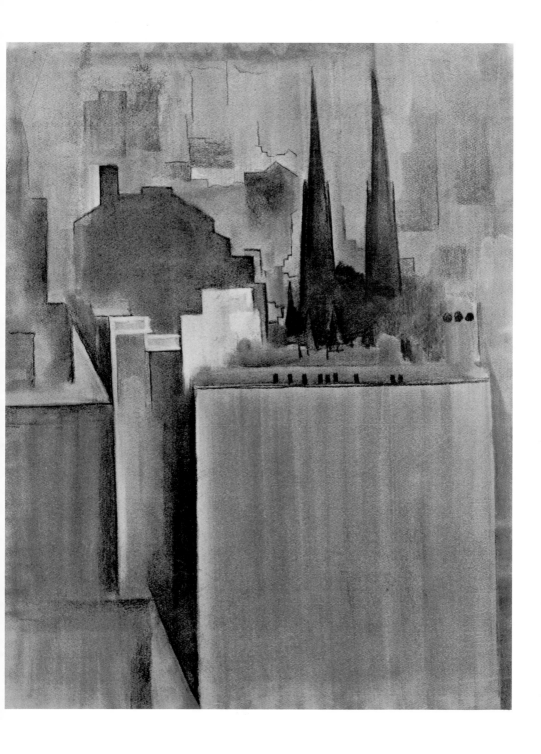

I first met Beauford Delaney when he was posing for Mary Callery. I found that he was a painter and posed for others because he had no heat in his studio and needed to keep warm. He seemed a very special sort of person so I began drawing him too.

I don't remember where I worked on him – maybe at Mary's – maybe in my own place. But I made several drawings and a couple of pastels of him.

15 BEAUFORD DELANEY. Early 1940's? Charcoal. 24¾ × 18⅝ inches

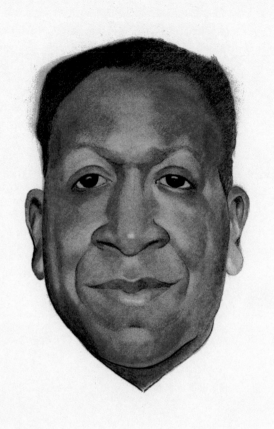

These horns are from my bone period and became paintings later.

16 GOAT'S HORNS II. 1945. Charcoal. 23½ × 18 inches

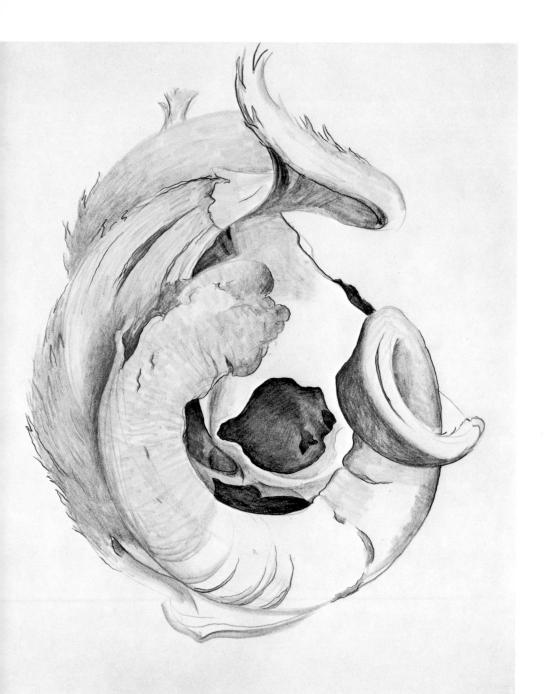

17 RAM'S HORNS II. Ca. 1949. Charcoal. 18⅝ × 24⅝ inches

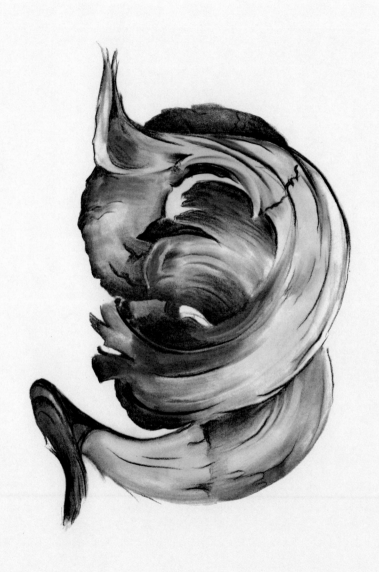

When I flew around the world I was surprised to see how many large spots of desert we went over – with a large river or river bed crossing over the sand. I made many drawings about an inch high – that later, when I was home, I made into larger drawings and after that paintings.

18　DRAWING I. 1959. Charcoal. 24⅝ × 18⅝ inches

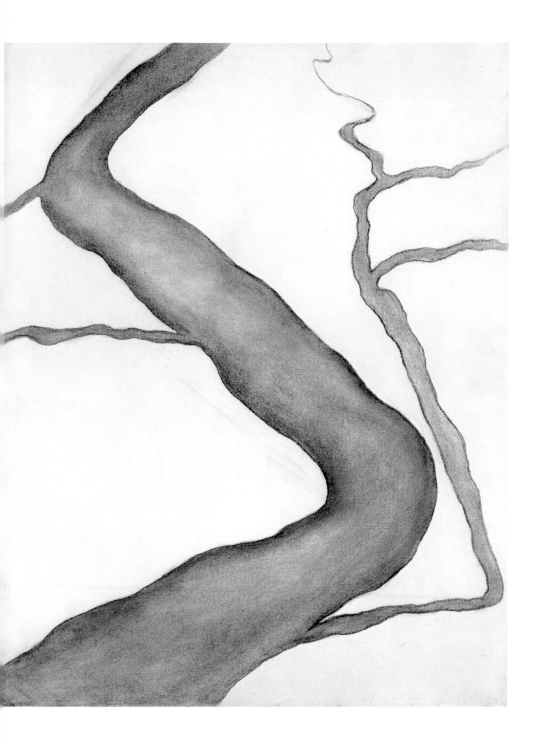

19 DRAWING III. 1959. Charcoal. 18⅝ × 24⅝ inches

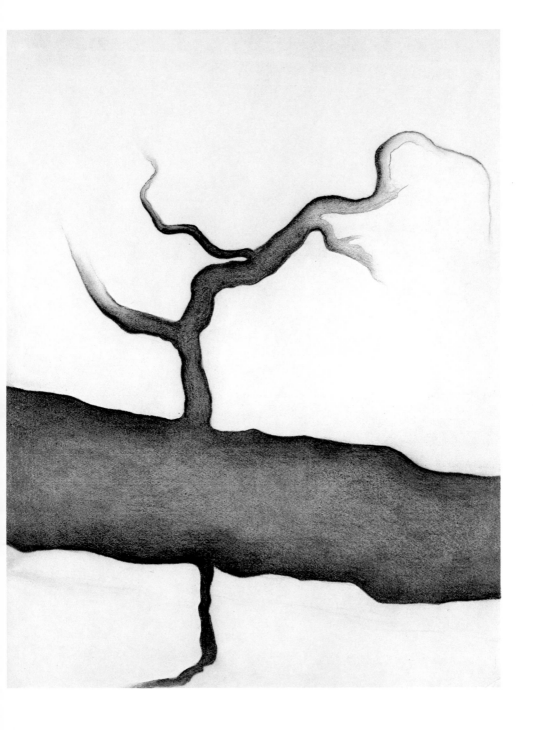

We had antelope at Ghost Ranch. Arthur Pack brought seven babies by plane down from Wyoming and raised them on bottles. The road from the Pack house to the main house was so bad that when it rained he had to ride over on a burro to get the fourteen gallons of milk to feed them. In time the antelope grew up and were set free. There was a very handsome buck among them and the herd grew.

One year there were seventeen down in the arroyo near the house where I was living. And every morning my big Chow went down to chase them – he galloping clumsily and yelping – the antelope floating lightly ahead of him as if they enjoyed giving him a run. I've had older ones race close past me like the wind when the herd was going in another direction to divert attention from the young.

After he had made a bit of trouble, the big buck was kept in a large pen in my backyard. I think he knew I was afraid of him. He would stand and look at me – come and eat from my hand – then hook my hand with his horn as if it were his natural gesture. Sometimes the coyote that was a pet of the house would be lying beside the pen like a dog.

When the buck saw me on a hilltop a mile away he would start toward me – probably because after he

grew up he was always fed by a woman. Two or three of the herd would sometimes follow my car – an open roadster – and I was always afraid they would jump on the back of it. At night they would stand close to the house and pant at my window. I had an old black stove poker that I always kept by my bed for fear they might jump in the window. Exactly what I thought I would do with the poker I don't know.

In time someone gave me a very fine antelope head with horns. It was supposed to be the old buck's head that had been shot. It was very easy to shoot an antelope because when it was startled it raised a good sized patch of white hair on its rear end as it began to run. They ran so lightly they seemed to float.

There were many drawings and paintings of the antelope. Our antelope had horns that turned back with a short forward prong. But I also had horns that turned in.

Later when the deer became friendly the antelope moved away – far to the west, over the hill beyond the highway.

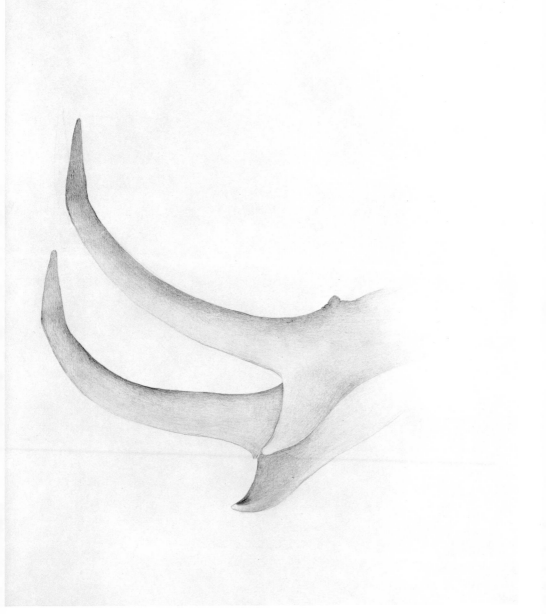

I live on a hilltop in a village of about two hundred Spanish-American people. From my eastern window the road out into the world seems to wind away far up and down. Nearby it seems to swoop under the house – then curves to the left instead and goes past me. The road winds along the foot of the hills at the edge of the mountains. A long dark mesa to the east – a ragged pink one to the west – a valley into the mountains to the south, then hills and a mountain to the north. In Peru that mountain would be called a rise of ground. Here it is called a mountain.

One day, playing with a camera, I tried to photograph the road and to get it all in I had to turn the camera at a very odd angle. My drawing – or painting – call it what you will – comes from that photograph.

21 THE WINTER ROAD. 1963. Oil on canvas. 22 × 18 inches

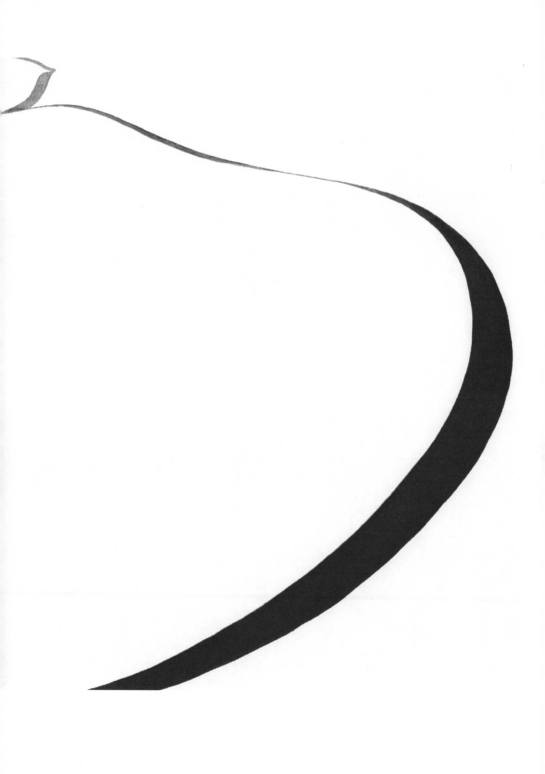

SOME NOTES ON THE PLATES

It seems of interest to set down some information which could otherwise be lost about Georgia O'Keeffe's participation in the reproductions I have published of her drawings, especially since a number of these plates do not correspond to the original works of art as they now appear. What might seem to be liberties, had I as publisher undertaken them, were changes made by O'Keeffe because for her they enhanced the relationship between the original drawing and the printed reproduction. Only the artist herself could have sanctioned such bold changes in composition, in scale, and in tonality.

Because these variations occurred during the course of the experimental work on my initial publication of the drawings—a large format portfolio*—the notes below relate principally to those plates. To the extent technically possible, they have been carried over to my later publications on the O'Keeffe drawings, first to the limited edition of *Some Memories of Drawings* (Atlantis Editions, 1974) and now to the present volume.

Plate 1 (*Blue Lines*). Although the large portfolio plates generally reproduced the drawings slightly reduced from their original size, *Blue Lines* did not look right in any proof with even the slightest reduction, so it was finally printed in actual size.

The plate turned out so well that O'Keeffe once told me to approve its loan to a museum that wanted to borrow the original, but not to tell them (which I did not do), because the original, housed in the Alfred Stieglitz Collection at the Metropolitan Museum of Art, had become discolored and very fragile. A look at the original, however, regardless of its condition, will show anyone that it retains its remarkable and unique character.

Plates 3 (*Abstraction IX*), 7 (*Drawing No. 13*), and 9 (*Drawing No. 12*). O'Keeffe often used fixative on these early charcoal draw-

*Georgia O'Keeffe. *Georgia O'Keeffe Drawings*. New York: Atlantis Editions, 1968.

ings, which over the years at times became a heavy yellow stain. They were proofed several ways prior to deciding on their final format. First they were done as the drawings now appear to the eye, showing the yellowed fixative shapes and the overall tones as an integral part of the drawing. The originals were then proofed using a filter which visually removed these. Both proofs of each of these drawings were then shown to O'Keeffe. For plates 3 and 7 she chose to retain the fixative. For plate 9, which had an overall tone and less fixative, O'Keeffe chose to lose the background entirely, remarking: "This is what I remember drawing," although the original as it now exists is covered with tone.

Plate 12 (*Drawing No. 40*). This drawing also did not look right with any reduction, so it was reproduced in its full size. As it was much smaller and more delicate than the other drawings, it was difficult to make it fit with the others in the portfolio. Finally a sheet of Copperplate paper (already in use for the plate folders) in the 25 × 19″ size of the portfolio was selected as a mount, O'Keeffe placed the proof on that sheet, and her placement was followed in the balance of the edition by tipping it in by hand. (This differentiation is unfortunately largely lost in the present publication.)

Plate 13 (*Banana Flower*). O'Keeffe's original drawing sheet measures 21¾×14¾″, far narrower than her usual format, and the drawn flower image almost bursts from the narrow sheet. When O'Keeffe was shown proofs, again we considered mounting them on a larger sheet to fit the portfolio box. Instead, she took a blank sheet of the 25 × 19″ portfolio paper and, placing the proof over it, suggested that the reproduction be printed directly on the full sheet, with the image position now changed from the original drawing. When I demurred, feeling that this might be a scholarly impropriety, she remarked that she could not help the accident that she had had a narrow pad of paper along the day she drew the banana flower, but that this was the way she liked it "today."